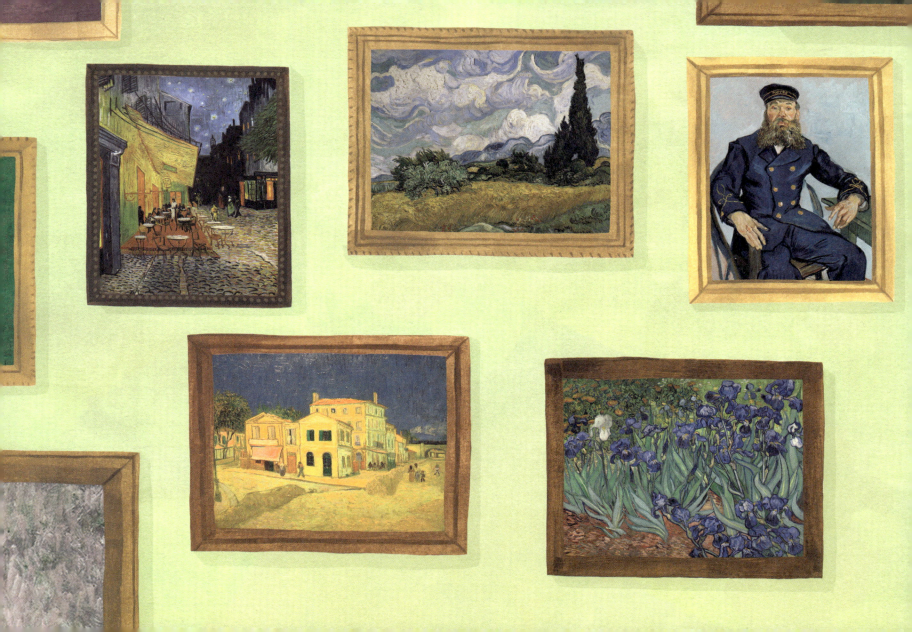

Introducing... Vincent van Gogh

You may have heard about an artist called Vincent van Gogh who cut off his own ear, but there is a great deal more to his story. One of the most famous and influential artists in history, he produced some of the most recognizable and popular art in the world. He lived during an incredibly exciting period in the history of art and played an important role in the development of the art movement known as Post-Impressionism.

Van Gogh's most famous works are from the ten-year period between 1880 and 1890, when he was at his most creative. He painted, among hundreds of other works, Sunflowers, The Starry Night, The Bedroom, A Wheatfield with Cypresses, and Café Terrace at Night. He also completed many self-portraits, the most famous of which is his Self-Portrait with Bandaged Ear, which can be seen on the fold-out timeline at the back of the book.

It was also during this time that Van Gogh began to struggle with his mental health. In 1888, after an argument with his friend, the artist Paul Gauguin, he cut off part of his ear and was admitted to a psychiatric hospital. Despite the deterioration in his health, he continued to paint almost obsessively until his death in 1890.

Art historians think that Van Gogh sold only one painting, *The Red Vineyard at Arles*, in his lifetime, yet he is now considered one of the greatest artists of all time.

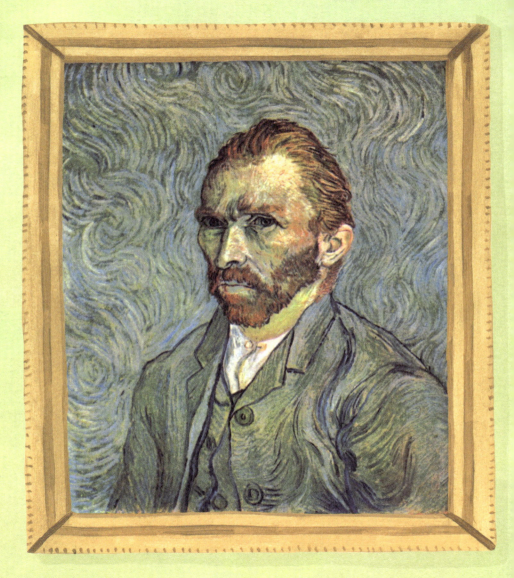

In this book you will discover the techniques that make Van Gogh's work so distinctive and complete activities to practice some of the master's methods for yourself.

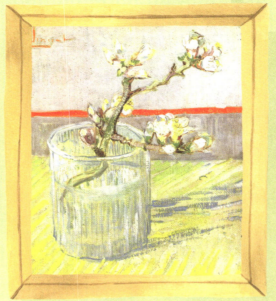

"I am always doing what I cannot do yet, in order to learn how to do it."
Vincent van Gogh

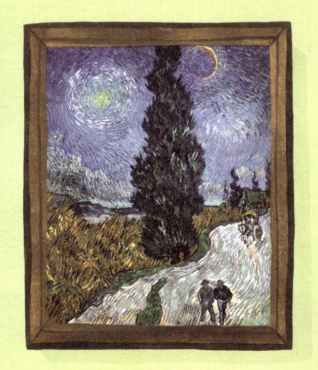

Some of the activities will give you a clear direction and a lot of guidance to help you, while others ask you to explore the techniques more freely and creatively.

You can practice the techniques described in this book and in your personal sketchbook to create your own Van Gogh-inspired artwork.

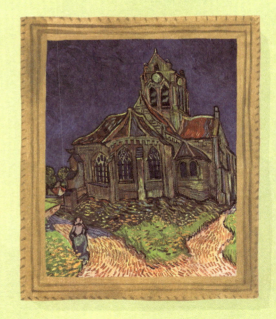

Post-Impressionism

Van Gogh is described as a 'Post-Impressionist', alongside artists such as Cézanne, Gauguin and Toulouse-Lautrec. All painted at the end of the 19th century, and some into the 20th century. Post-Impressionism is often said to be the foundation of modern art.

Impressionist artists left their studios and painted scenes from everyday life on the spot. Post-Impressionist artists got their name because they were influenced by, and then rebelled against, the Impressionists.

Post-Impressionists wanted their work to express meaning and emotion, rather than to capture scenes realistically. They did this by using bold, simple colors, and simplified or stylized shapes. They tried to capture non-visual elements in their paintings, such as an atmosphere or a noise.

Think about a scene from your day. Pick a sound, smell or feeling and, as you sketch the scene, try to capture that element in your drawing through your use of line, shape and color.

Gentle, flowing lines feel serene, while geometric shapes in a hard, thick line are more dynamic. Strong, solid colors convey more intense feelings than a lighter, softer palette.

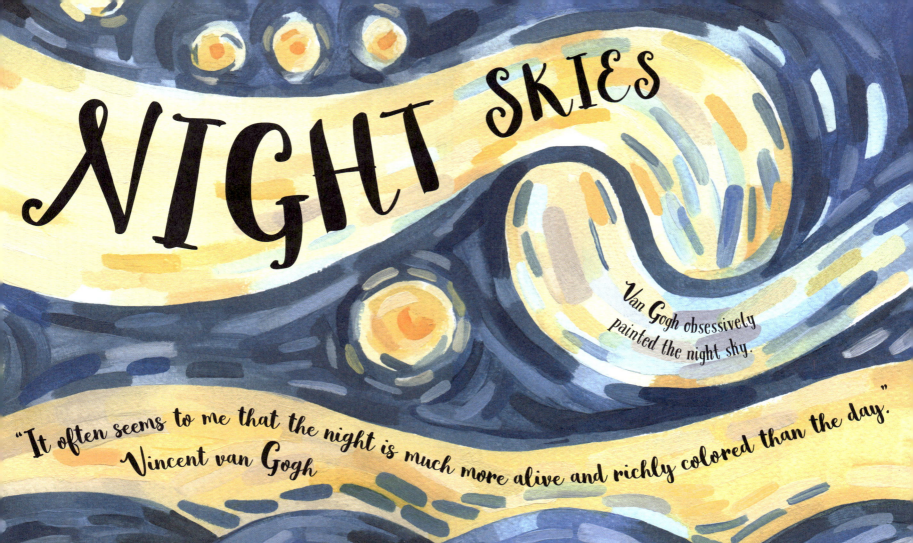

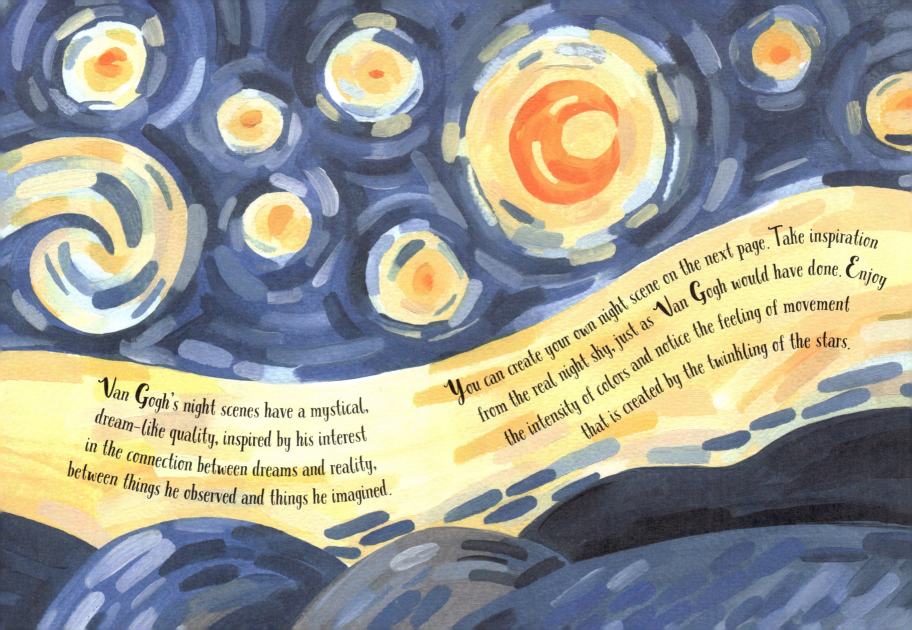

Van Gogh's night scenes have a mystical, dream-like quality, inspired by his interest in the connection between dreams and reality, between things he observed and things he imagined.

You can create your own night scene on the next page. Take inspiration from the real night sky, just as Van Gogh would have done. Enjoy the intensity of colors and notice the feeling of movement that is created by the twinkling of the stars.

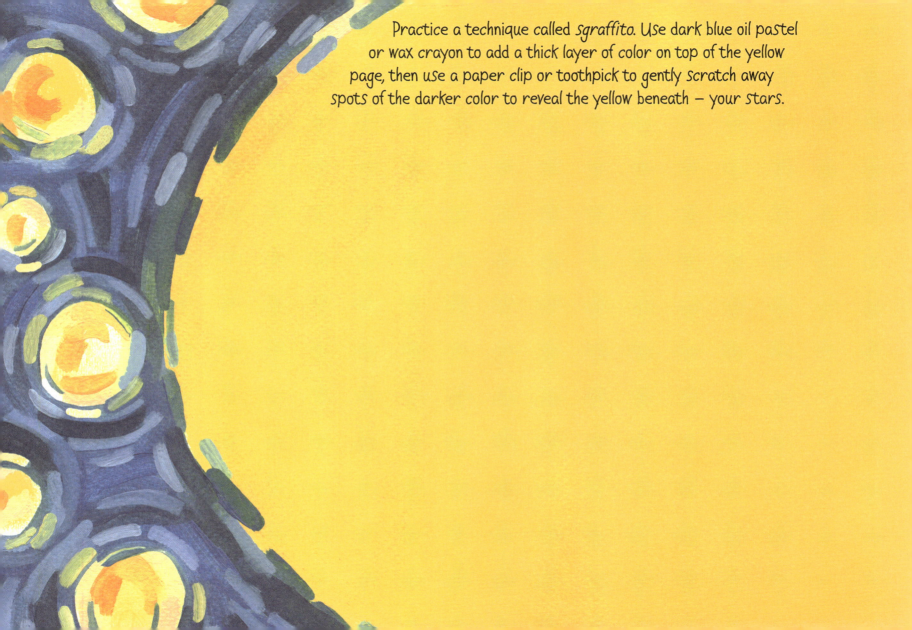

Practice a technique called *sgraffito*. Use dark blue oil pastel or wax crayon to add a thick layer of color on top of the yellow page, then use a paper clip or toothpick to gently scratch away spots of the darker color to reveal the yellow beneath — your stars.

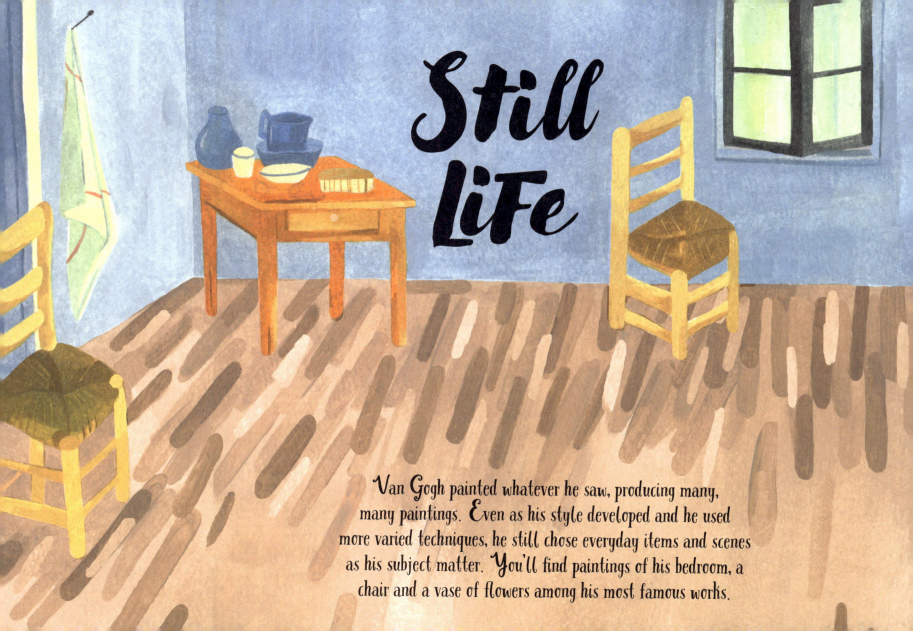

Still Life

Van Gogh painted whatever he saw, producing many, many paintings. Even as his style developed and he used more varied techniques, he still chose everyday items and scenes as his subject matter. You'll find paintings of his bedroom, a chair and a vase of flowers among his most famous works.

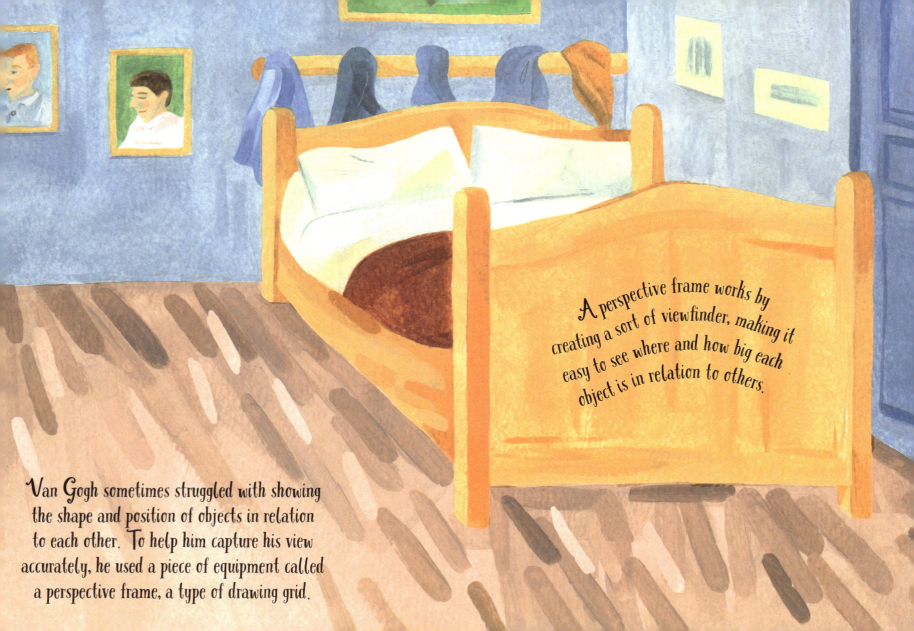

A perspective frame works by creating a sort of viewfinder, making it easy to see where and how big each object is in relation to others.

Van Gogh sometimes struggled with showing the shape and position of objects in relation to each other. To help him capture his view accurately, he used a piece of equipment called a perspective frame, a type of drawing grid.

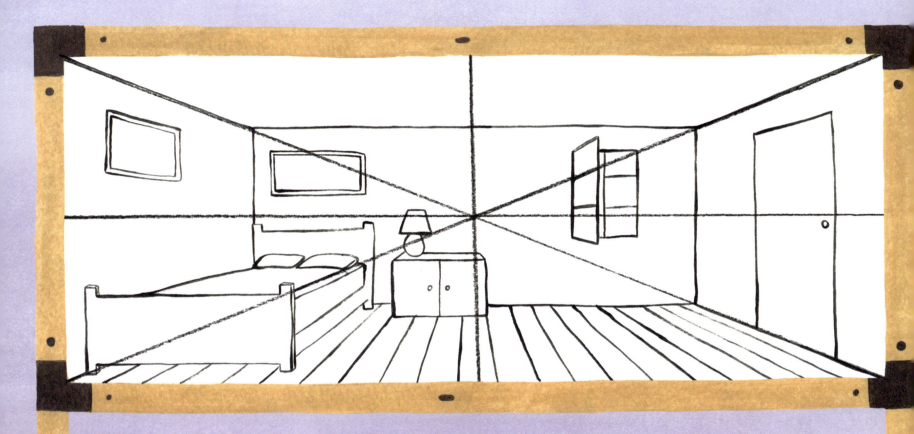

Van Gogh's perspective frame consisted of
a wooden frame on legs with string pulled tight
across the middle in vertical, horizontal and
diagonal lines. He used these to guide him.

Copy the picture on the opposite page, section by section, using the lines to help with the placement and size of the objects. Color it afterward if you want to disguise the lines.

Japonaiserie

Japanese printmaking was an important source of inspiration for Van Gogh. He fell in love with Japanese art shortly before he moved to Paris in 1886, filling his studio with woodcut prints called 'ukiyo-e'.

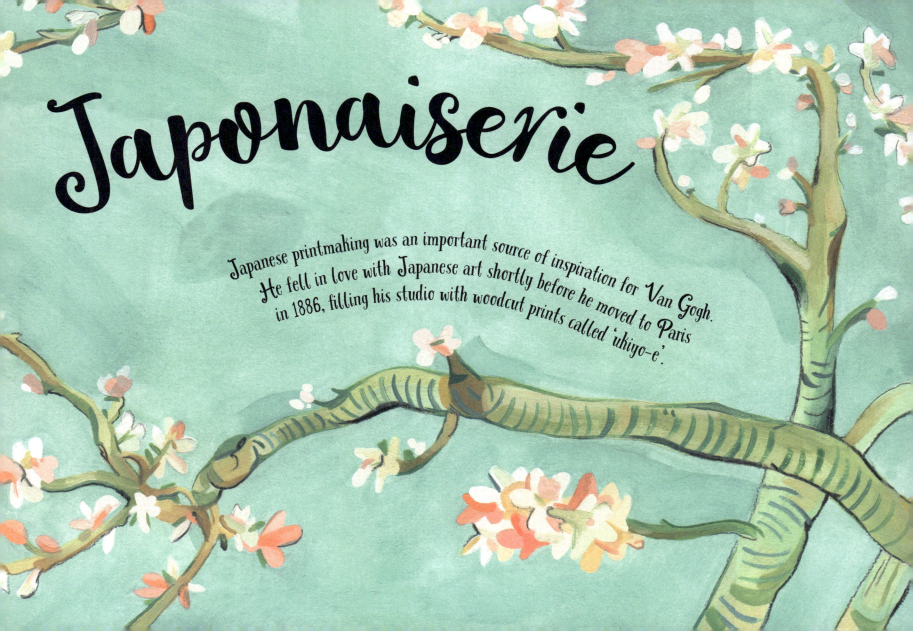

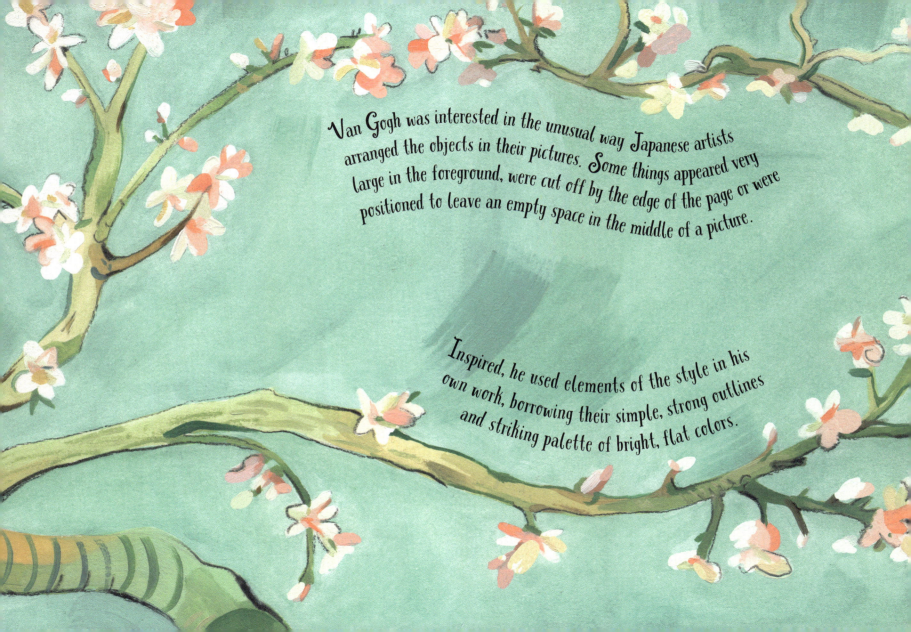

Van Gogh was interested in the unusual way Japanese artists arranged the objects in their pictures. Some things appeared very large in the foreground, were cut off by the edge of the page or were positioned to leave an empty space in the middle of a picture.

Inspired, he used elements of the style in his own work, borrowing their simple, strong outlines and striking palette of bright, flat colors.

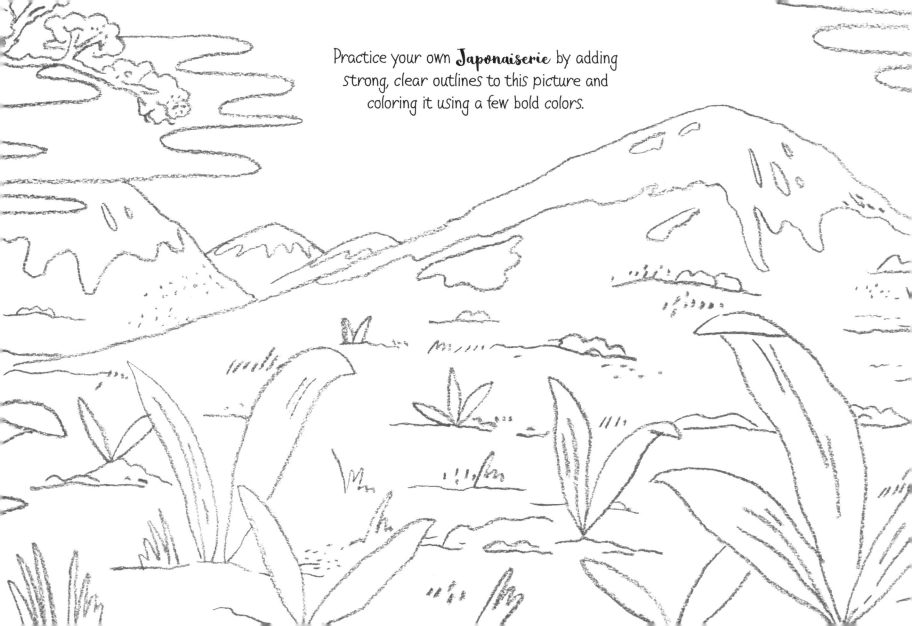

Practice your own **Japonaiserie** by adding strong, clear outlines to this picture and coloring it using a few bold colors.

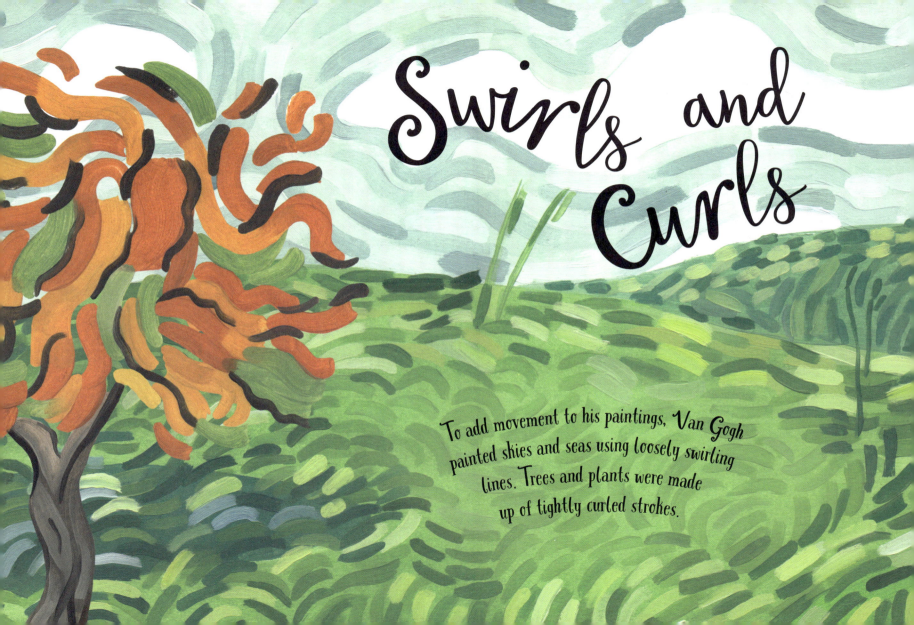

Swirls and Curls

To add movement to his paintings, Van Gogh painted skies and seas using loosely swirling lines. Trees and plants were made up of tightly curled strokes.

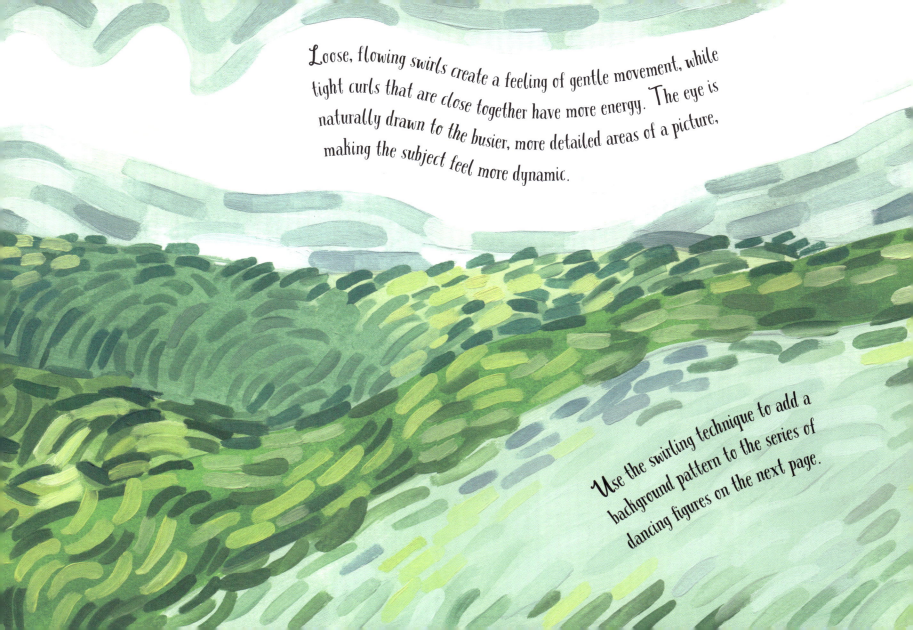

Loose, flowing swirls create a feeling of gentle movement, while tight curls that are close together have more energy. The eye is naturally drawn to the busier, more detailed areas of a picture, making the subject feel more dynamic.

Use the swirling technique to add a background pattern to the series of dancing figures on the next page.

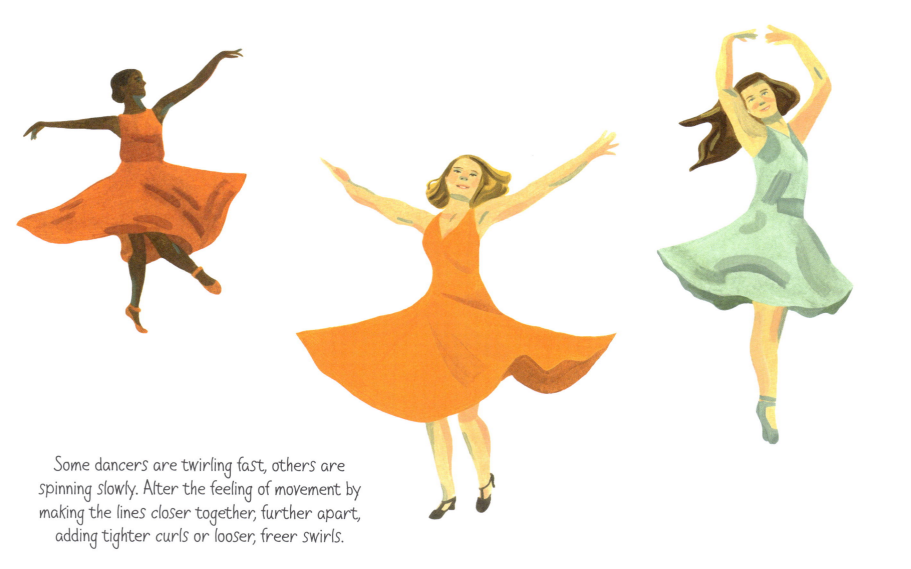

Some dancers are twirling fast, others are spinning slowly. Alter the feeling of movement by making the lines closer together, further apart, adding tighter curls or looser, freer swirls.

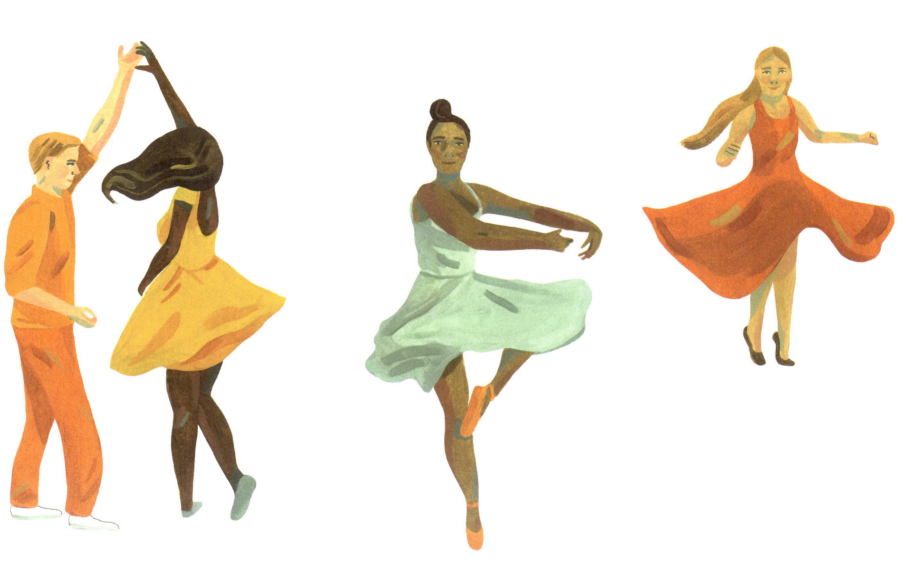

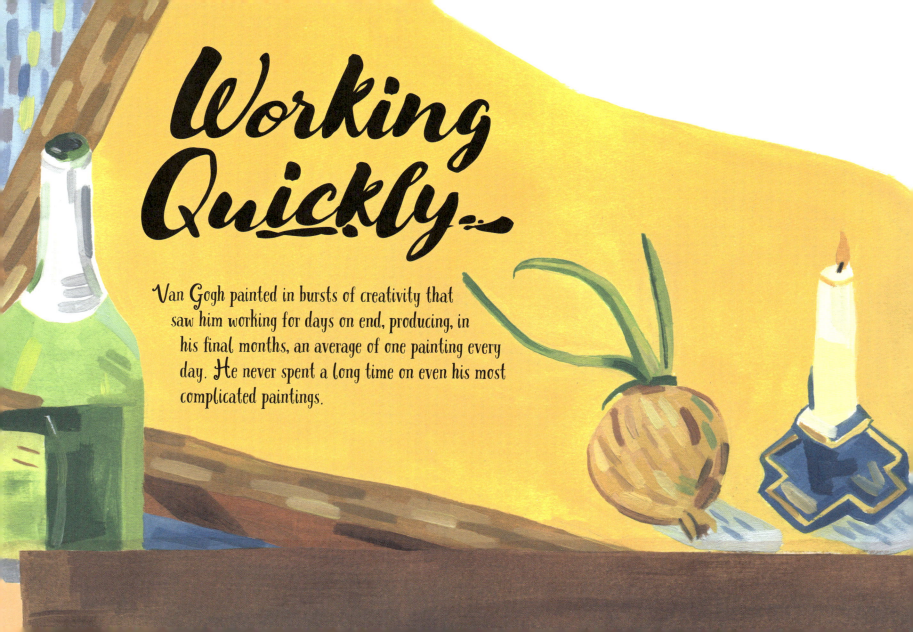

Working Quickly...

Van Gogh painted in bursts of creativity that saw him working for days on end, producing, in his final months, an average of one painting every day. He never spent a long time on even his most complicated paintings.

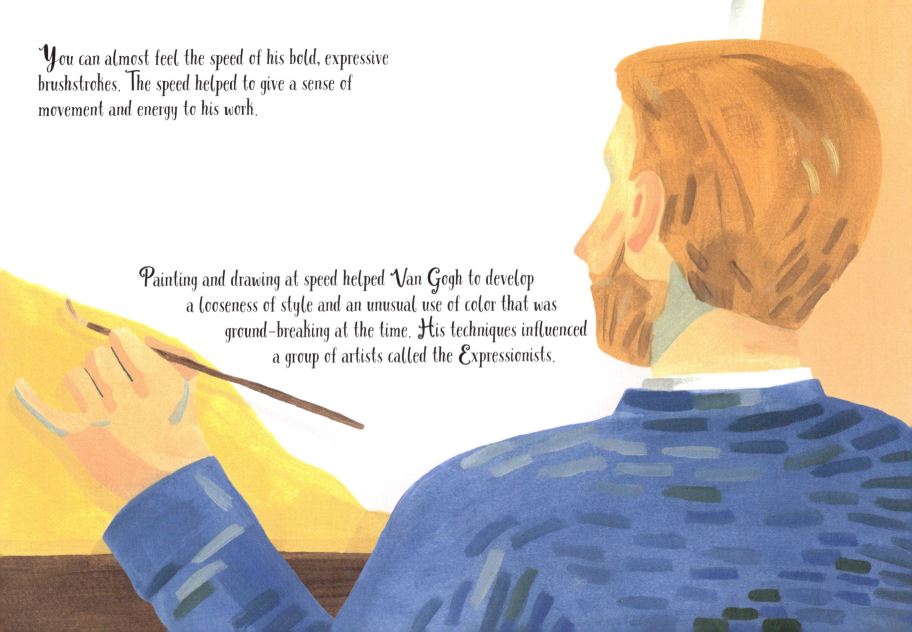

You can almost feel the speed of his bold, expressive brushstrokes. The speed helped to give a sense of movement and energy to his work.

Painting and drawing at speed helped Van Gogh to develop a looseness of style and an unusual use of color that was ground-breaking at the time. His techniques influenced a group of artists called the Expressionists.

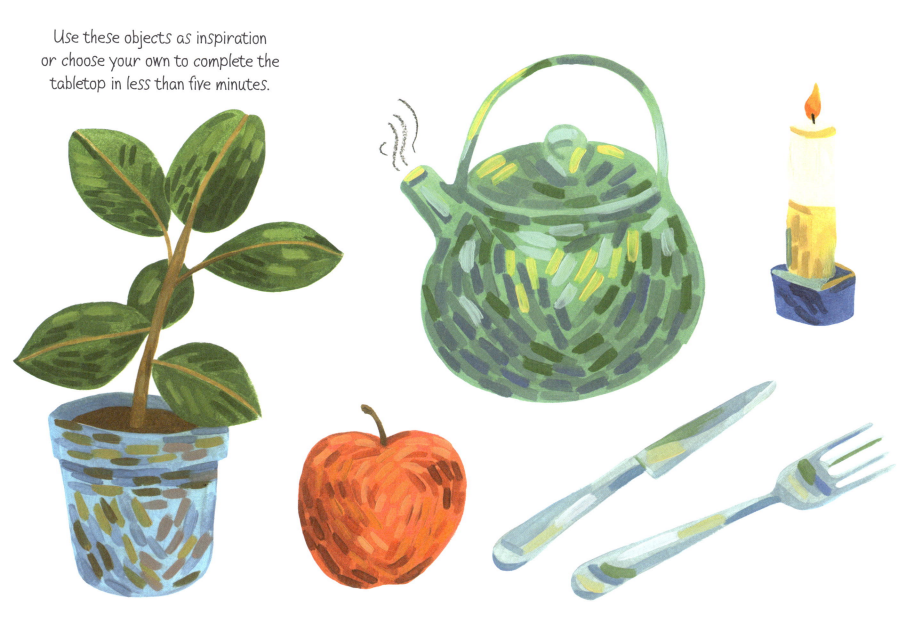

Don't overthink the positioning of the objects on the table.

Pointillism

As his style developed, Van Gogh experimented with different types of brushstroke, influenced by his friends and fellow artists Georges Seurat and Paul Signac. They pioneered a new technique called 'Pointillism', using dots of color to build up pictures.

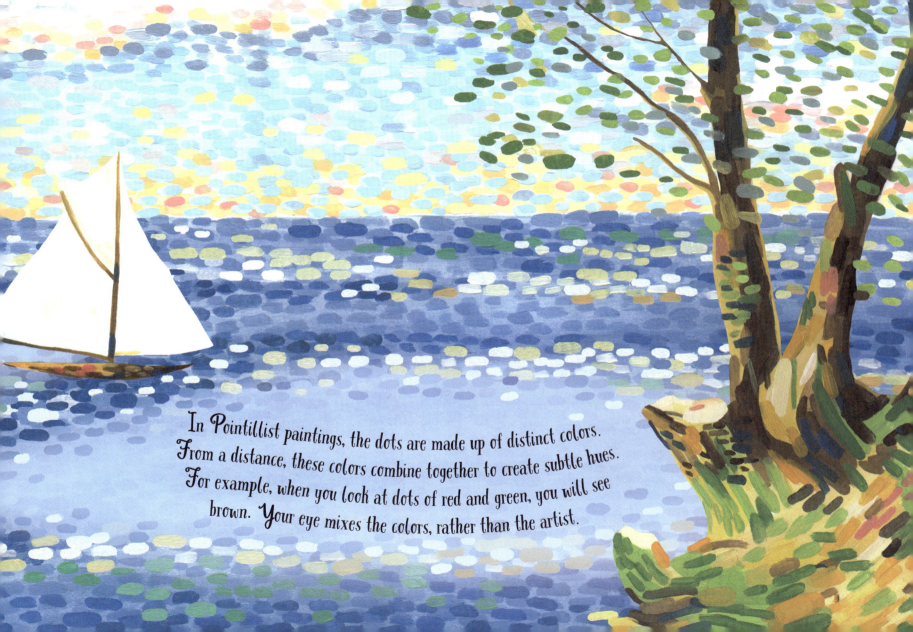

In Pointillist paintings, the dots are made up of distinct colors. From a distance, these colors combine together to create subtle hues. For example, when you look at dots of red and green, you will see brown. Your eye mixes the colors, rather than the artist.

Add a colorful pattern to the butterfly's wings.

Give this tree some fall foliage.

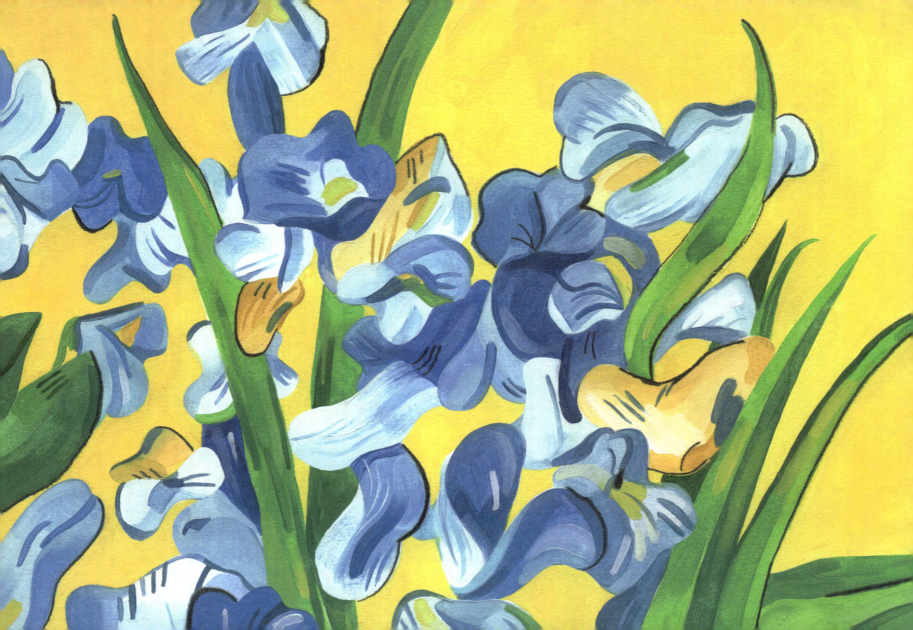

Complementary Colors

Over time, Van Gogh went from using dark and somber colors to using bright, 'complementary' colors to bring his paintings to life. Complementary colors are pairs of colors that produce the strongest contrast when placed next to each other. Blue and yellow appear side by side in many of his paintings.

"There is no blue without yellow, and without orange." Vincent van Gogh

Van Gogh had discovered that complementary color combinations are particularly pleasing to the eye. This is because they balance each other out, stimulating different parts of the eye at the same time. It's a clever trick!

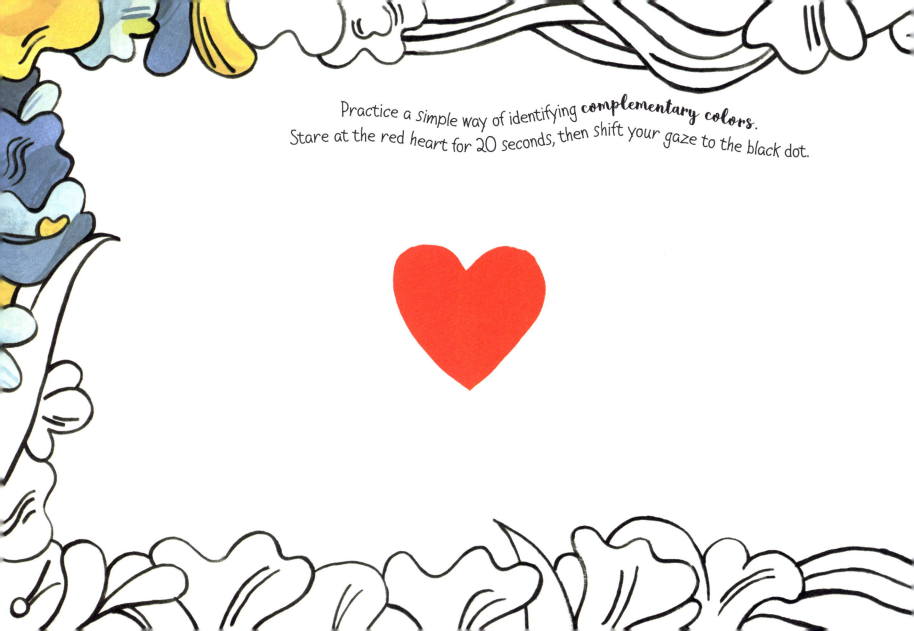

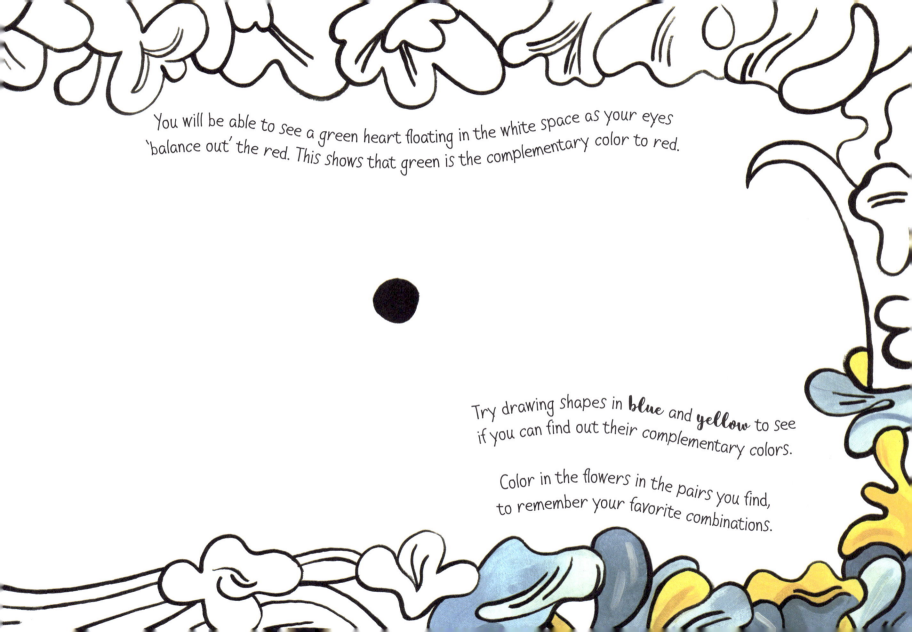

You will be able to see a green heart floating in the white space as your eyes 'balance out' the red. This shows that green is the complementary color to red.

Try drawing shapes in **blue** and **yellow** to see if you can find out their complementary colors.

Color in the flowers in the pairs you find, to remember your favorite combinations.

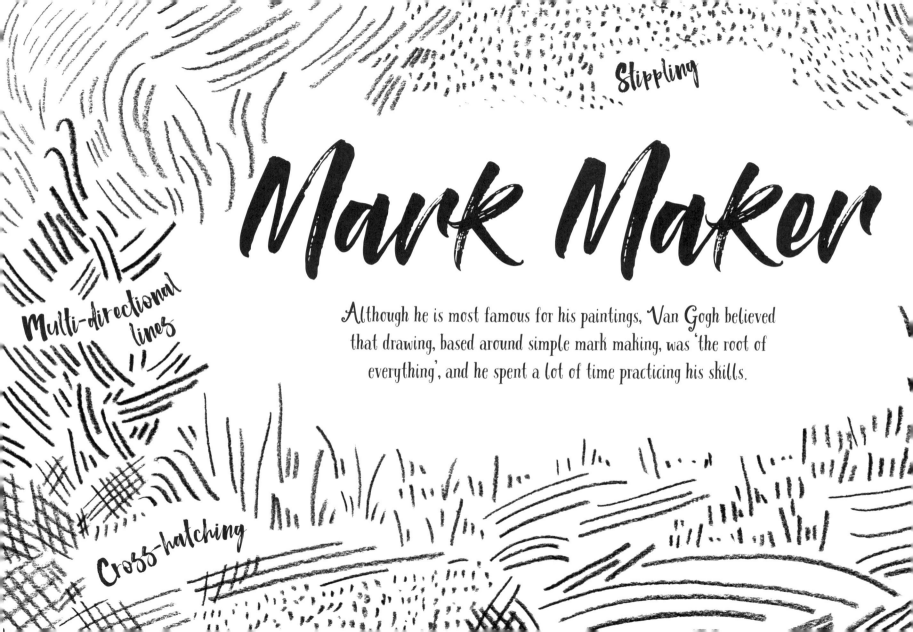

Mark Maker

Stippling

Multi-directional lines

Cross-hatching

Although he is most famous for his paintings, Van Gogh believed that drawing, based around simple mark making, was 'the root of everything', and he spent a lot of time practicing his skills.

Van Gogh's marks are so stylized and distinctive that his drawings are instantly recognizable. By using simple marks and lines, but altering their direction, thickness and length, he managed to create a huge variety of textures and shapes.

He drew in pencil, chalk and charcoal. His marks were stand-alone and rarely blended or merged with each other.

Soft, wavy lines

Using charcoal or a soft pencil, complete these drawings using different types of marks to add movement and texture.

A windmill with rotating blades.

A swishy-tailed, long-haired dog.

A glowing crescent moon in a stormy sky.

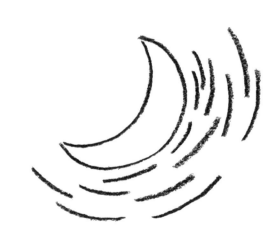

An explosive firework.

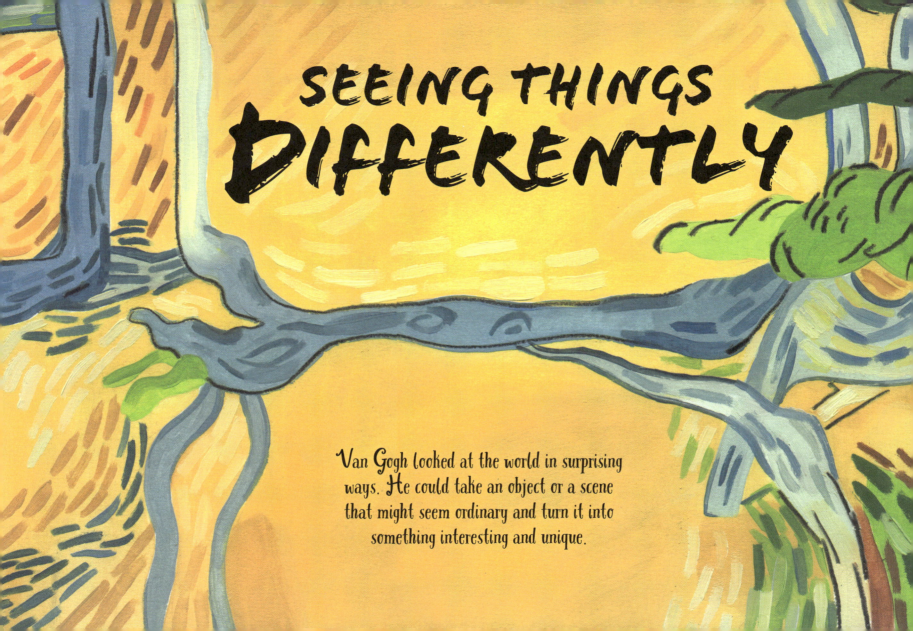

SEEING THINGS DIFFERENTLY

Van Gogh looked at the world in surprising ways. He could take an object or a scene that might seem ordinary and turn it into something interesting and unique.

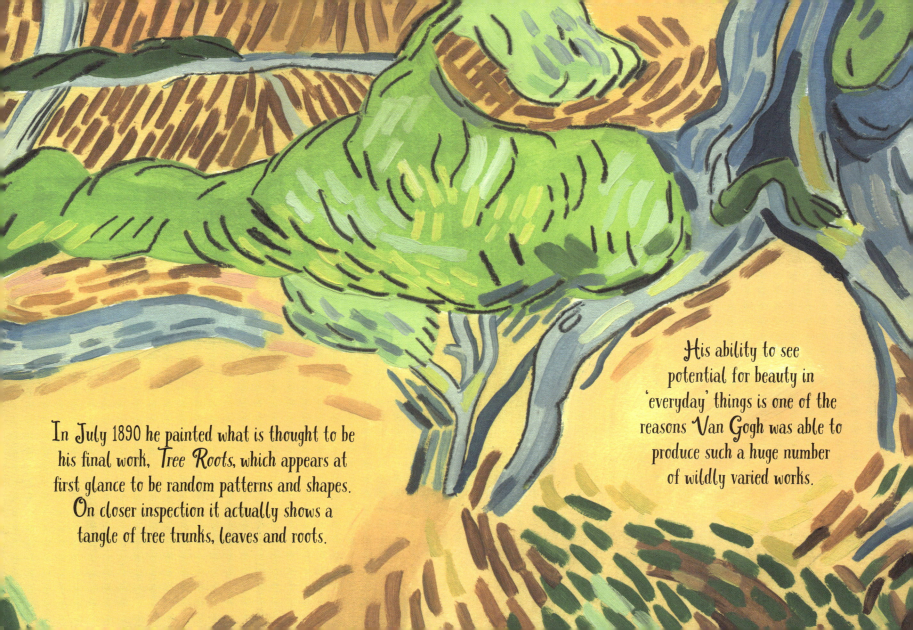

In July 1890 he painted what is thought to be his final work, *Tree Roots*, which appears at first glance to be random patterns and shapes. On closer inspection it actually shows a tangle of tree trunks, leaves and roots.

His ability to see potential for beauty in 'everyday' things is one of the reasons *Van Gogh* was able to produce such a huge number of wildly varied works.

Look out of the window.
Choose a tiny detail of your view and fill these pages with your representation of it.
Pay special attention to color, texture, light and shadow and any unusual shapes that form.

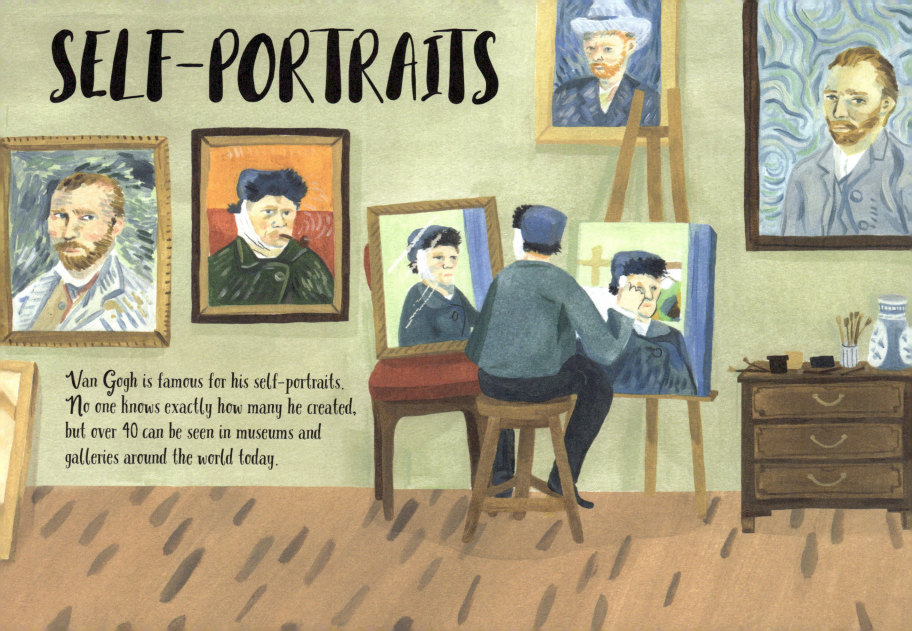

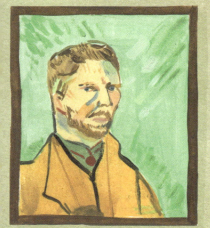
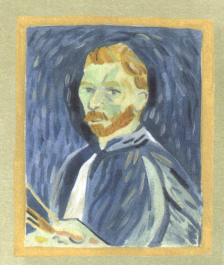

He used self-portraits as a way of practicing portraits without having to pay models to sit for him. One of his most famous paintings shows him just weeks after he had cut off part of his ear. The bandage looks like it is on the wrong ear because he painted his self-portraits while looking in a mirror.

Although every portrait is different, Van Gogh used some common elements in all of them, such as a serious, intense gaze and his distinctive red hair.

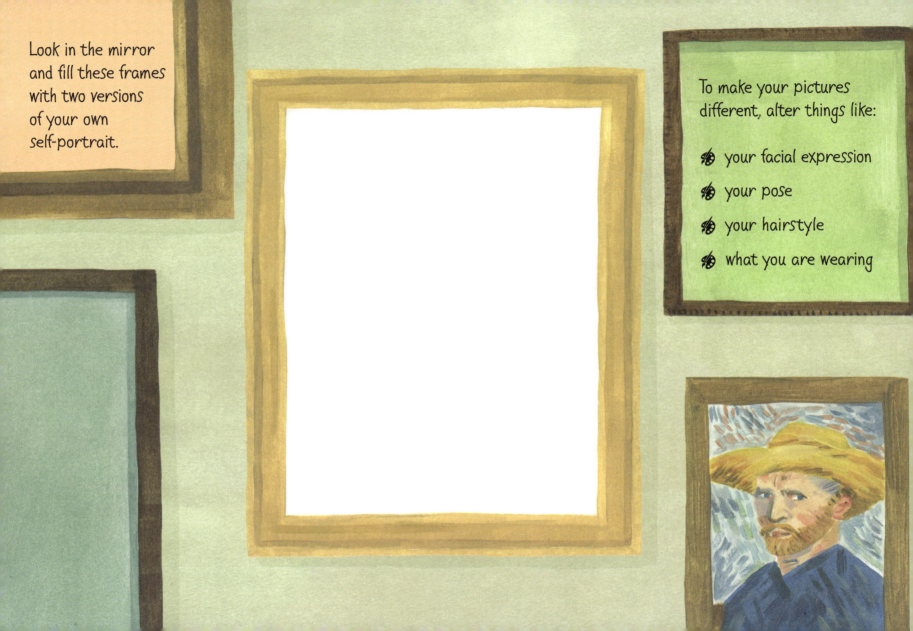

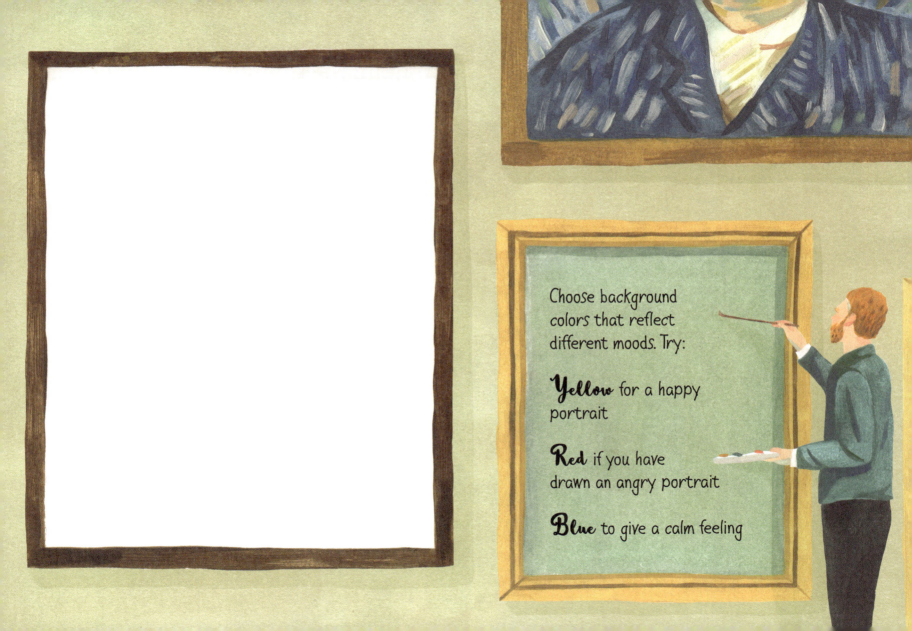

Choose background colors that reflect different moods. Try:

Yellow for a happy portrait

Red if you have drawn an angry portrait

Blue to give a calm feeling

Van Gogh was friends with an artist named Paul Gauguin, whose work he admired greatly. They lived together in Arles, France, in 1888, in a house known as the "Yellow House", and they had a huge impact on each other's work.

Gauguin favored clear, strong outlines and painted lots of tropical scenes using pure, bright colors. He encouraged Van Gogh not to be too realistic and to incorporate imaginary or even fantastical elements into his work.

Inspired by Gauguin's suggestion that he try painting from memory, Van Gogh's work became looser in style and more imaginative.

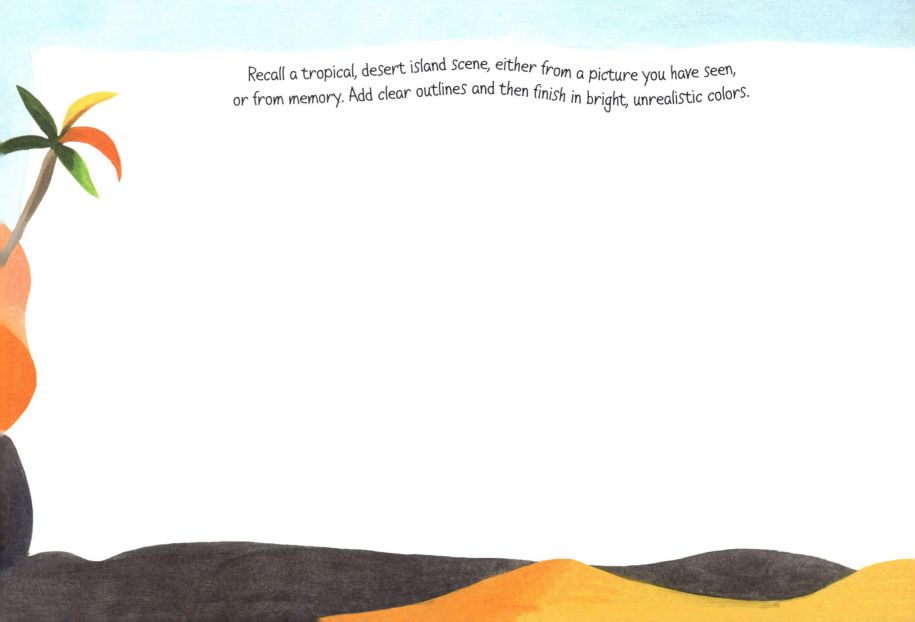

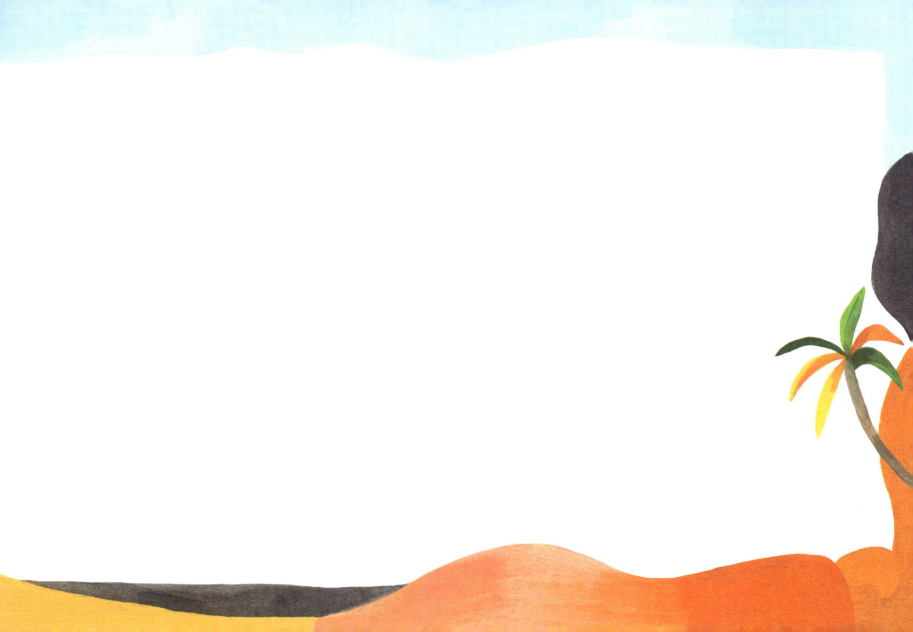

Painting with Words

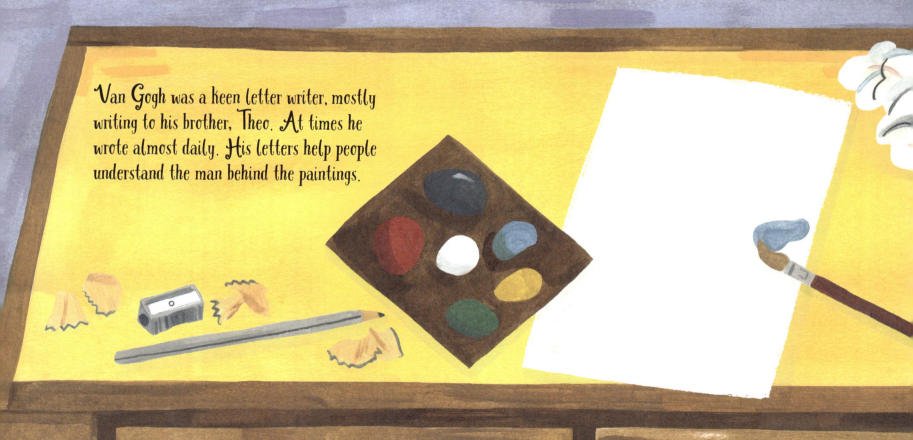

Van Gogh was a keen letter writer, mostly writing to his brother, Theo. At times he wrote almost daily. His letters help people understand the man behind the paintings.

The letters themselves are almost like miniature works of art—Van Gogh often added pictures to his writing. He made sketches of recently completed paintings or pictures he was still working on.

His writing style was almost as vivid as his finished canvases. His words bring to life the people and places he painted.

Write a letter to someone you know, describing a place you have visited. Focus on the things that stand out in your memory, particularly the non-visual elements such as smells, sounds or voices.

Expressionism

Van Gogh wanted to capture a certain mood or emotion with the colors that he chose. His creative use of color played an important role in the development of what were to become famous movements in art history — Fauvism and Expressionism.

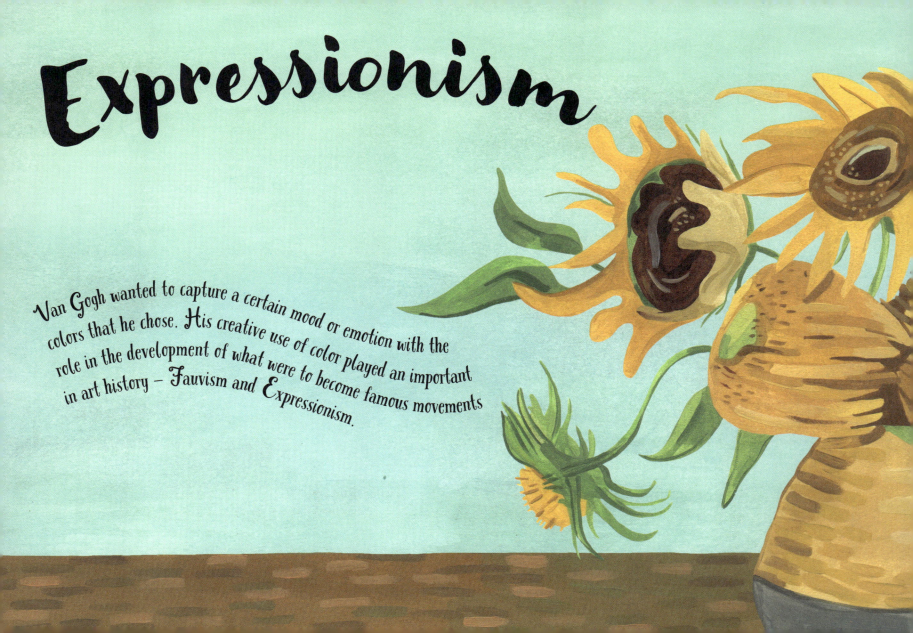

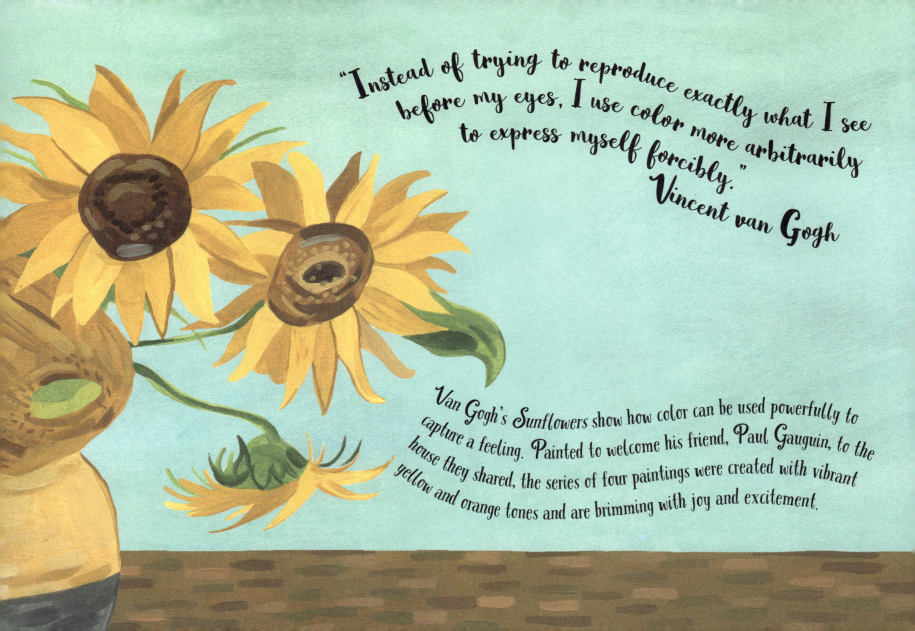

"Instead of trying to reproduce exactly what I see before my eyes, I use color more arbitrarily to express myself forcibly."
Vincent van Gogh

Van Gogh's Sunflowers show how color can be used powerfully to capture a feeling. Painted to welcome his friend, Paul Gauguin, to the house they shared, the series of four paintings were created with vibrant yellow and orange tones and are brimming with joy and excitement.

Color these sunflowers without thinking about how they should look. Instead, choose shades that reflect how you feel right now.

In Context

Despite his relatively short career, Vincent van Gogh had a huge impact on many artists who came after him. Elements of his unique style, and the styles of other members of the Post-Impressionist movement such as Paul Gauguin and Georges Seurat, can be seen in the work of artists to this day. They are credited with laying the foundations of modern art as we now know it.

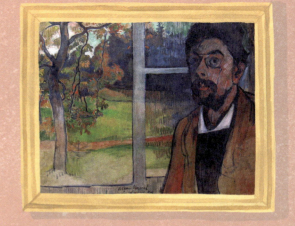

Charles Laval sent this self-portrait to Van Gogh, who praised it in a letter to his brother, Theo.

Self-Portrait (1888) Van Gogh Museum, Amsterdam

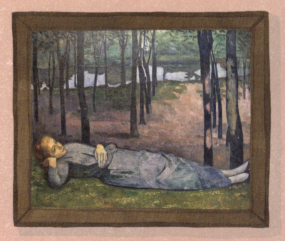

Émile Bernard eliminated excessive detail, preferring strong lines and bold colors.

Madeleine au Bois d'Amour (1888) Musée d'Orsay, Paris

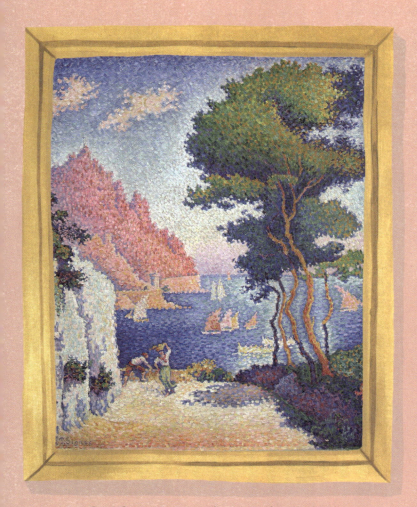

Paul Signac created shapes without relying on line, which gave his work an abstract feel.

Capo di Noli (1898) Wallraf-Richartz-Museum, Cologne

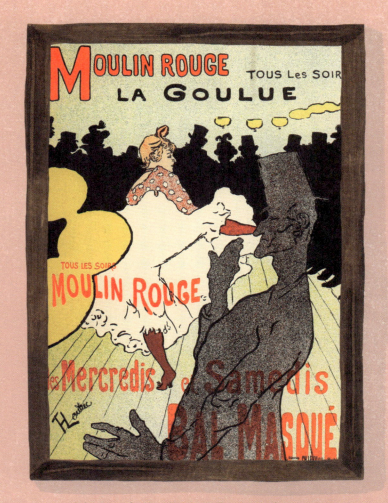

Like Van Gogh, Henri de Toulouse-Lautrec was inspired by Japanese woodcut prints to create dramatic compositions featuring flat color and silhouettes.

Moulin Rouge - La Goulue (1891)

Illustrated by Grace Helmer
Written and edited by Jocelyn Norbury
Designed by Jack Clucas
Cover design by John Bigwood and Angie Allison

Manufacturer: First published in Great Britain in 2018 by LOM ART. This edition published in 2025 by LOM ART, an imprint of Michael O'Mara Books Limited, 9 Lion Yard, Tremadoc Road, London SW4 7NQ
www.mombooks.com

Represented by: Authorised Rep Compliance Ltd, Ground Floor,
71 Lower Baggot Street, Dublin D02 P593, Ireland
www.arccompliance.com

W www.mombooks.com/lom
F Michael O'Mara Books
I @lomart.books

Copyright © Michael O'Mara Books 2018, 2024

All rights reserved. You may not copy, store, distribute, transmit, reproduce or otherwise make available this publication (or any part of it) in any form, or by any means (electronic, digital, optical, mechanical, photocopying, recording, machine readable, text/data mining or otherwise), without the prior written permission of the publisher. Any person who does any unauthorized act in relation to this publication may be liable to criminal prosecution and civil claims for damages.

A CIP catalogue record for this book is available from the British Library.

ISBN: 978-1-915751-45-4

1 3 5 7 9 10 8 6 4 2

This product is made of material from well-managed, FSC®-certified forests and other controlled sources. The manufacturing processes conform to the environmental regulations of the country of origin.

Printed in May 2025 by Leo Paper Products Ltd, Heshan Astros Printing Limited,
16 YanJiang Road, Gulao Town, Heshan City, Guangdong Province, China

For further information see www.mombooks.com/about/sustainability-climate-focus
Report any safety issues to product.safety@mombooks.com

Page 2: *Café Terrace at Night* (1888), Kröller-Müller Museum, Otterlo, Netherlands and *Postman Joseph Roulin* (1888), Museum of Fine Arts, Boston; The Yorck Project: 10,000 Meisterwerke der Malerei, DIRECTMEDIA Publishing GmbH. *Wheatfield with Cypresses* (1889), Metropolitan Museum of Art, New York; Everett – Art/ Shutterstock.com. *The Yellow House* (1888), Rijksmuseum Vincent van Gogh, Amsterdam; Multichill/Wiki Loves Art/NL/cc by-sa 2.0. *Irises* (1889), The J. Paul Getty Museum, Los Angeles; Digital image courtesy of the Getty's Open Content Program.

Page 4: *Self-Portrait* (1889), Musée d'Orsay, Paris; The Yorck Project: 10,000 Meisterwerke der Malerei, DIRECTMEDIA Publishing GmbH.

Page 5: *Road with Cypress and Star* (1890), Kröller-Müller Museum, Netherlands, *Blossoming Almond Branch in a Glass* (1888), Rijksmuseum Vincent van Gogh, Amsterdam and *The Church at Auvers-sur-Oise* (1890) Musée d'Orsay, Paris ; The Yorck Project: 10,000 Meisterwerke der Malerei, DIRECTMEDIA Publishing GmbH.

Page 62: Sailko/cc by-sa 3.0.

Page 63: Top left: Pimbrils/ Wiki Loves Art/NL/cc by-sa 2.0. Bottom left: Sharon Mollerus/ Wiki Loves Art/NL/cc by-sa 2.0.

Timeline
Top row (left to right) Xanne/ Wiki Loves Art/NL/cc by-sa 2.0; The Yorck Project: 10,000 Meisterwerke der Malerei, DIRECTMEDIA Publishing GmbH; Junjiali/Pixabay/cc0; The Yorck Project: 10,000 Meisterwerke der Malerei, DIRECTMEDIA Publishing GmbH. Bottom row (left to right) The Yorck Project: 10,000 Meisterwerke der Malerei, DIRECTMEDIA Publishing GmbH; Niels/ Wiki Loves Art/NL/cc by-sa 2.0; Courtesy of Judith Palmer; MicheleLovesArt/ Wiki Loves Art/NL/cc by-sa 2.0.